The Pre-Raphaeli[tes]

by Leslie Parris

TATE GALLERY published by Order of the Trustees 1973

ISBN 0 900874 48 1
Copyright © 1966 Tate Gallery. Reprinted 1968. Revised edition 1973.
Published by the Publications Department, The Tate Gallery, Millbank, London,
SWIP 4RG.
Printed in Great Britain by Balding & Mansell, London and Wisbech.

LIST OF PLATES

15 Frederic George Stephens
Mother and Child. c. 1854–5
Canvas, $18\frac{7}{8} \times 25\frac{1}{8}$ in. (4634)

16 Dante Gabriel Rossetti
*The Wedding of St. George and
Princess Sabra.* 1857
Watercolour, 14×14 in. (3058)

17 James Collinson
The Empty Purse,
replica of *For Sale. c.* 1857
Canvas, $24 \times 19\frac{3}{8}$ in. (3201)

18 Ford Madox Brown
Chaucer at the Court of Edward III
1856–67
Canvas, $48\frac{1}{2} \times 39$ in. (2063)

19 Ford Madox Brown
Carrying Corn. 1854
Panel, $7\frac{3}{4} \times 10\frac{7}{8}$ in. (4735)

20 Ford Madox Brown
The Last of England. 1864–6
Watercolour, 14×13 in. (3064)

21 William Lindsay Windus
Too Late. 1857–8
Canvas, $37\frac{1}{2} \times 30$ in. (3597)

22 Arthur Hughes
The Woodman's Child. 1860
Canvas, $24 \times 25\frac{1}{4}$ in. (T.176)

23 Arthur Hughes
April Love. 1855–6
Canvas, $35 \times 19\frac{1}{2}$ in. (2476)

24 Arthur Hughes
*Aurora Leigh's Dismissal of Romney
('The Tryst').* Finished 1860
Panel, $15\frac{1}{4} \times 12$ in. (5245)

25 Robert Braithwaite Martineau
Kit's Writing Lesson. 1852
Canvas, $20\frac{1}{2} \times 27\frac{1}{2}$ in. (T.11)

26 Walter Howell Deverell
A Pet. Exhibited 1853
Canvas, $38\frac{1}{8} \times 22\frac{1}{2}$ in. (2854)

27 Henry Wallis
Chatterton. 1856
Canvas, $24\frac{1}{2} \times 36\frac{3}{4}$ in. (1685)

28 William Dyce
*Pegwell Bay, Kent—A Recollection
of October 5th 1858.* 1859–60
Canvas, 25×35 in. (1407)

29 Thomas Seddon
*Jerusalem and the Valley of
Jehoshaphat.* 1854
Canvas, $26\frac{1}{2} \times 32\frac{3}{4}$ in. (563)

30 John Brett
Glacier of Rosenlaui. 1856
Canvas, $17\frac{1}{2} \times 16\frac{1}{2}$ in. (5643)

31 Sir Edward Burne-Jones Bt.
Clara von Bork, 1560. 1860
Watercolour, $13\frac{1}{4} \times 7$ in. (5878)

32 Sir Edward Burne-Jones Bt.
Sidonia von Bork, 1560. 1860
Watercolour, $13 \times 6\frac{3}{4}$ in. (5877)

33 Sir Edward Burne-Jones Bt.
King Cophetua and the Beggar Maid.
Finished 1884
Canvas, $115\frac{1}{2} \times 53\frac{1}{2}$ in (1771)

34 William Morris
Queen Guinevere. 1858
Canvas, $28\frac{1}{4} \times 19\frac{3}{4}$ in. (4999)

The Pre-Raphaelites

Left to right:
(i) Millais
(ii) Rossetti
(iii) Hunt

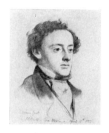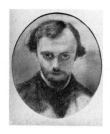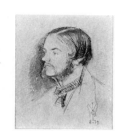

The 'Pre-Raphaelite Brotherhood' was formed in 1848 by William Holman Hunt (1827–1910), John Everett Millais (1829–96), Dante Gabriel Rossetti (1828–82), James Collinson (?1825–81), Thomas Woolner (1825–92), Frederic George Stephens (1828–1907) and William Michael Rossetti (1828–1919). The first of its monthly meetings was held that autumn, and in 1849 Hunt, Millais and D. G. Rossetti exhibited their first pictures bearing the monogram 'P.R.B.'. Four numbers of a magazine entitled *The Germ* (for its last two issues *Art and Poetry*) were published in 1850.

The members of the Brotherhood tended to see themselves as revolutionaries. 'Our talk is the deepest treason against our betters', Hunt once confided to Millais' mother. They determined, he said, 'to do battle against the frivolous art of the day', especially sentimental pictures of dogs and choir-boys, and against 'approved imitations of the Greeks, and paintings that would ape Michael Angelo and Titian'. Instead there was to be 'a child-like reversion from existing schools to Nature herself'. Stephens noted in *The Germ* that there had already been 'a marked attempt to lead the taste of the public into a new channel by producing pure transcripts

and faithful studies from nature, instead of conventionalities and feeble reminiscences from the Old Masters; an entire seeking after originality in a more humble manner than has been practised since the decline of Italian Art in the Middle Ages'. But, he added, this had been attempted only by landscape painters, and their example should be followed by 'their fellow-labourers, the historical painters'. The Pre-Raphaelites' aims were summed up by W. M. Rossetti as '1, To have genuine ideas to express; 2, to study Nature attentively, so as to know how to express them; 3, to sympathize with what is direct and serious and heartfelt in previous art, to the exclusion of what is conventional and self-parading and learned by rote; and 4, and most indispensable of all, to produce thoroughly good pictures and statues'.

The personalities of the Brethren were too dissimilar for their association to be more than short-lived. In November 1853 Christina Rossetti wrote a sonnet beginning 'The P.R.B. is in its decadence', but the group had started to disintegrate long before. Collinson resigned at Whitsun 1850, and in the following December Stephens and W. M. Rossetti were lamenting 'the shamefully obsolete condition into which P.R.B. meetings have fallen'. There was not even agreement on the spelling of the Brotherhood's name: Hunt wrote 'Pre-Raphaelite', W. M. Rossetti 'Præraphaelite'. By January 1851 its significance was being debated. The members then proposed 'that each of us should write a manifesto declaring the sense in which he accepts the name; to be read all together at our next meeting'. Only W. M. Rossetti actually did so, and he later lost the document.

Hunt's talk of a 'reversion from existing schools' did not mean that the Pre-Raphaelites were ignorant of previous art. They were fairly well acquainted with early Italian and Flemish painting, from which their name derived, and they were aware of its more pedantic revival earlier in the century by the German Nazarene artists. At the same time their taste extended to other periods. A list of 'Immortals' drawn up by D. G. Rossetti

and Hunt in 1848 ranged from Christ to Tennyson and included Raphael, Titian, Tintoretto, Poussin, Hogarth, Flaxman, Haydon, Wilkie and Ary Scheffer. On the Continent in 1849 Rossetti sang the praises of van Eyck, Memling, Ingres, Delaroche and Gavarni, while in 1855 he thought Delacroix 'the greatest painter of modern times'. The P.R.B.s admired and were admired by many of their professional elders in England. They received active encouragement from Mulready, Linnell, J. F. Lewis—established masters of minute naturalistic detail—Dyce, Egg, and their close associate Ford Madox Brown.

Pre-Raphaelite techniques were not wholly novel. Wilkie's pupil Claude Lorrain Nursey explained to Hunt how his master painted *The Blind Fiddler* 'without any dead colouring, finishing each bit thoroughly in the day', and Hunt immediately adopted the method. Turner, Mulready, Etty and others had already used white grounds to obtain brilliance of colour, while the Pre-Raphaelites' occasional use of wet white grounds reflected contemporary interest in fresco painting. There was already a trend towards brighter pigments. After seeing some watercolours by J. F. Lewis in 1834 Cotman had cried 'My poor *Reds, Blues and Yellows* . . . are *faded jades* to what I saw there'. Ruskin, describing an Italian scene in the first volume of *Modern Painters* (1843), almost programmed a Holman Hunt: 'I cannot call it colour, it was conflagration. Purple, and crimson, and scarlet, like the curtains of God's tabernacle . . . every separate leaf quivering with buoyant and burning life'. The theoretical basis of Pre-Raphaelitism had also been voiced by Ruskin when he attacked the 'theatrical, affected, and false in art' and pointed to the alternative, Nature. Hunt felt that *Modern Painters* had been written expressly for him. Not least, the Pre-Raphaelites' demand for serious subjects was yet another echo of Reynolds' advocacy of an art which would 'raise the thoughts, and extend the views of the spectator'.

The Pre-Raphaelite pictures exhibited in 1849 were on the whole well-

received, but Millais' contribution to the Royal Academy of 1850 caused an outcry, which was repeated in the following year. However, Coventry Patmore secured the support of Ruskin, who wrote two letters to *The Times* and a pamphlet on Pre-Raphaelitism. With his defence, and some concessions by Millais to public taste, William Michael Rossetti could report in January 1853: 'Our position is greatly altered. We have emerged from reckless abuse to a position of general and high recognition'.

Of the seven members of the Brotherhood, Holman Hunt was most consistent in the pursuit of seriousness of subject and fidelity to nature. Son of a London warehouse manager, he spent four years in City offices before his father allowed him to become a full-time art student. After two unsuccessful attempts he was admitted to the Royal Academy Schools in 1844. One of his early employers had been the reformer Richard Cobden: although Hunt disagreed with his views on free-trade, and even wrote to the newspapers accordingly, Cobden's example 'encouraged me to value the cultivation of a larger ambition than that of the mere making of a personal fortune'—an 'ambition to do public service'. He and Millais accompanied the Chartist procession of 1848. Hunt believed he knew what was wrong with society, and from *The Hireling Shepherd* onwards sought to express a form of Christian socialism in his pictures. (Earlier, for example in *Claudio and Isabella* (1850–3, pl.2), his concern is less directly stated.)

At first sight *The Hireling Shepherd* (1851, City Art Gallery, Manchester) is a straightforward scene of rustic lovers: but it was intended as 'a rebuke to the sectarian vanities and vital negligences of the day'. For Hunt 'lovers with only personal interest should not be represented for public attention'. The shepherd here typifies the 'muddle headed pastors who instead of performing their services to the flock—which is in constant peril—discuss vain questions of no value to any human soul'. The Death's Head Moth he has found fills him with superstitious forebodings, and his girl-friend 'scorns his anxiety from ignorance rather than profoundity'. She 'only the

more distracts his faithfulness: while she feeds her lamb with sour apples his sheep have burst bounds, and got into the corn'.

But this moralizing is at odds with the picture. The moth and sour apples do little to diminish the attractiveness of the lovers' situation as Hunt has painted it: in spite of himself, he issues an invitation, not a rebuke. The contradiction was inevitable when he aimed also 'to paint—not dresden china bergers, but—a real shepherd, and a real shepherdess, and a landscape in full sunlight, with all the colour of luscious summer' (letter in the City Art Gallery, Manchester). This aspect of the picture is a complete and novel success, and is sustained in the associated work *Our English coasts, 1852* ('*Strayed Sheep*') (1852, cover), which, Ruskin said, 'showed to us, for the first time in the history of art, the absolutely faithful balances of colour and shade by which actual sunlight might be transposed'. It is also a simpler and more effective pictorial metaphor of the untended flock than *The Hireling Shepherd*. In '*Strayed Sheep*', in fact, he had little opportunity for complicated symbolism, because his patron asked simply for a repetition of the group of sheep in the other picture, though Hunt substituted a fresh composition. These circumstances made it an exceptional work. Otherwise he continued to paint elaborately symbolic pictures, notably two allegories on salvation, *The Light of the World* (1851–4, Keble College, Oxford) and *The Awakening Conscience* (1853–4, The Trustees of Sir Colin and Lady Anderson), in which one feels again a discrepancy between the moral and its expression: in the second picture Hunt paints the *maison damnée* with loving care.

In later works he resolved this conflict to his disadvantage. The need to preach overwhelmed more painterly responses. Despite intensive research in Palestine in 1854–6 (the first of four such expeditions), *The Finding of the Saviour in the Temple* (1854–60, City Museum and Art Gallery, Birmingham) remained a studio construction. Carefully studied accessories did not supply an oriental atmosphere, or give more than superficial

identities to his figures. The latter became increasingly stereotyped. Rubber-limbed and wide-eyed, the curly horrors in *The Triumph of the Innocents* (1883–4, pl.3) are as mannered as the 'pictured waxworks' which provoked Hunt in 1848.

Millais was never sanctimonious about his art. Given every opportunity to become a painter, he won the Silver Medal of the Society of Arts at the age of nine, entered the Royal Academy Schools as their youngest ever pupil at ten, and received the Gold Medal for painting at seventeen. His facility was prodigious. Upon the formation of the P.R.B. he abandoned a style derived largely from Etty, and painted his first Pre-Raphaelite picture, *Isabella* (1848–9, Walker Art Gallery, Liverpool) 'at a pace beyond all calculation'. Flatly modelled and deliberately awkward in design, it is closer, superficially at least, to 'primitive' art than any of Hunt's pictures, and closer also to Nazarene painting. In *Christ in the House of His Parents* (1849–50, pl.4) Millais tried to be 'Early Christian' in spirit as well. His friendship with the Oxford Tractarians, Thomas Combe—whom he actually addressed as 'The Early Christian'—and his wife, may have been responsible for the unusual degree of involvement he seems to have had with his subject in this case. Angularities of composition and gesture used gratuitously in *Isabella* here create an appropriate feeling of mystery. The figure of Christ, one hand raised to display his prefigurative wound and the other held at right angles to it across the body in a gesture of separation from his mother, is a wonderfully eloquent invention un-equalled elsewhere in Millais' work. The ritualistic attitudes of the figures gain point by contrast with the detailed realism with which they and their surroundings are painted. But Millais' uncompromising treatment of this sacred subject was not well received at the Academy in 1850, and many found it blasphemous. 'The attempt to associate the holy family', wrote *The Times* critic, 'with the meanest details of a carpenter's shop, with no conceivable omission of misery, of dirt, of even disease, all finished

with the same loathsome minuteness, is disgusting . . .'.

Although he gradually lost interest in the minute handling of his early Pre-Raphaelite work, Millais remained true throughout the 1850s to the Brotherhood's ideal of expressing 'genuine ideas'. The ideas were often of a painful kind, with the subject of fated love well to the fore: weary Mariana wishing she were dead (*Mariana*), mad Ophelia singing as she drowns (pl.6), the last meeting of a Catholic girl and her Huguenot lover on St. Bartholomew's Day (*A Huguenot*), an equally final parting on the eve of Waterloo (*The Black Brunswicker*). But it was this sort of subject matter that established Millais' reputation with the public. *A Huguenot* (1851–2, Private Collection) created a sensation when it was shown in 1852: 'crowds stood before it all day long', wrote F. G. Stephens, 'Men lingered there for hours, and went away but to return. It had clothed the old feelings of men in a new garment'. *The Order of Release, 1746* (1852–3, pl.5), a more straightforward celebration of womanhood, needed a policeman to keep its admirers on the move in 1853. The same year Millais was elected an A.R.A., the first step on the path that was to lead him to the Presidency of the Royal Academy in 1896. However, his position in the 1850s was not always an easy one, and the public did not immediately accept some of his finest pictures. The intensely poetical *Autumn Leaves* (1855–6, City Art Gallery, Manchester) was thought too vague, and *The Vale of Rest* (1858–9, pl.8), which again contrasts the transience of human life with the beauty of natural appearances, remained unsold for several years.

Although often regarded as the leader of the Brotherhood, Rossetti was unsympathetic to its aims and later saw his membership as mainly social. He attended the Antique School of the Royal Academy from 1846 to the spring of 1848, when he studied briefly under Ford Madox Brown. Later that year he became Hunt's pupil and under his supervision painted *The Girlhood of Mary* (1848–9, pl.9). However, both this and *Ecce Ancilla Domini* (*The Annunciation*) (1849–50, pl.10), which does not bear the

P.R.B. monogram, are un-Pre-Raphaelite in their pale colour, idealized figures and lack of detail, and show the influence, through Brown, of Nazarene painting: Hunt called them Overbeckian. Most important of all, they show how little Rossetti was interested in the nature which Hunt and Millais courted—typically, the lily in the second picture was painted from an artificial flower. His only attempt at a naturalistic, moral subject in the manner of Hunt, *Found* (1853–82, Wilmington Society of the Fine Arts, Wilmington, Delaware), was left unfinished after years of painful labour. 'D. G. Rossetti', wrote his sister Christina, 'shuns the vulgar optic.'

He withdrew into an imaginary world, inspired by intense reading of Dante, the Bible, Malory, Shakespeare, Keats, Browning and Tennyson. Difficulties with the technique of oil-painting made him adopt water-colour, a medium in which he felt freer to describe his richly-coloured, airless world according to its own mysterious laws of light and perspective. The subjects he chose reflected a vision of ideal love which, as in his own life, had turned sour and become fatalistic. In his poem *The Orchard Pit* the woman who gives to men 'her magic hour of ease' wears in her breasts 'the ravishing eyes of Death'; the poet loves 'as in the maelstrom's cup'. In *Paolo and Francesca* (1855, Tate Gallery) the lovers pay for their moment of happiness by being driven through the raining fire of hell by incessant winds. The princess in *The Wedding of St. George and Princess Sabra* (1857, pl.16) seems to look through her saviour's embrace to the grinning head of the dead dragon. At the same time Rossetti took mystic refuge in the idea of love transcending death. In *Dante's Dream at the Time of the Death of Beatrice* (1856, Tate Gallery) Dante is shown the dead Beatrice but sees that she is at peace because, as symbolized in *Dantis Amor* (1859, pl.11), in paradise she 'gazes continually on the face of Him who is through all ages blessed'. In heaven too Dante is reunited with Beatrice. Added point was given to Rossetti's obsession with these ideas when his wife, Elizabeth Siddal, died in 1862 after a short and unhappy marriage. *Beata*

Beatrix (begun 1863, pl.12), depicting Beatrice at the moment when she is 'suddenly rapt from earth to heaven', was painted in memory of her.

Beata Beatrix was one of the first of many oils and large watercolours of female figures, usually rather vacuous in design and vapid in characterization compared with the earlier watercolours. Rossetti's mood remained morbid. The merciless woman *Lady Lilith* (begun 1864, Wilmington Society of the Fine Arts, Wilmington, Delaware) 'Draws men to watch the bright web she can weave, Till heart and body and life are in its hold'. *Proserpine* (1874, pl.14) languishes in the underworld and *La Pia* (*c.* 1868–81, University of Kansas Museum of Art) in malarial marshes.

The other members of the P.R.B. have only marginal importance. Stephens painted a few pictures before becoming a full-time art critic. *Mother and Child* (*c.* 1854–5, pl.15) is the best of them. W. M. Rossetti, who did not paint at all, was a civil servant, secretary to the P.R.B., editor of *The Germ*, art critic, and patient historian of his brother and the Brotherhood. Collinson was introduced to the P.R.B. by Rossetti and his *The Renunciation of Queen Elizabeth of Hungary* (1850–1, Johannesburg Art Gallery) seems closer to the latter's early religious paintings than to Pre-Raphaelitism proper. He resigned from the group in 1850 on the grounds that membership compromised his Catholicism, and retired to Stoneyhurst. When he resumed his career in 1854 he painted such anecdotal subjects as *The Empty Purse* (*c.* 1857, pl.17). Woolner the sculptor is remembered for his portrait-busts and medallions, though in what sense they are Pre-Raphaelite is unclear.

Although not actually a member, Ford Madox Brown (1821–93) was closely associated with the Brotherhood. Born at Calais, he studied at the Academies of Bruges, Ghent and Antwerp. His early pictures were painted in what he called a 'sombre Rembrandtesque style', but after seeing works by Holbein at Basle and visiting the Nazarenes Cornelius and Overbeck in Rome in 1845 he adopted a lighter palette for *Chaucer at the Court of*

Edward III (1847–51, Art Gallery of New South Wales, Sydney; replica, 1856–68, pl.18). It was, Brown said, the first picture 'in which I endeavoured to carry out the notion, long before conceived of treating the light and shade absolutely as it exists at any one moment, instead of approximately, or in generalised style'. This desire for naturalism was encouraged by his friendship with Hunt and Millais, to whom he was introduced by Rossetti in 1848. He took up their interest in *plein-air* painting in a series of small sunlit landscapes, including *Carrying Corn* (1854, pl.19), in which he used even hotter, brighter colour than Hunt. He also went further than Hunt by painting figures in the open air, for example in *The Pretty Baa Lambs* (1851–9, City Museum and Art Gallery, Birmingham). Brown said that the latter had no 'meaning beyond the obvious one . . . I should be much inclined to doubt the genuineness of that artist's ideas who never painted from love of the mere look of things, whose mind was always on the stretch for a moral. This picture was painted out in the sunlight; the only intention being to render that effect as well as my powers in a first attempt of that kind would allow'.

Yet he was concerned with social problems. In *The Last of England* (1852–5, City Museum and Art Gallery, Birmingham; replica, 1864–6, pl.20), which was suggested by Woolner's departure for Australia in 1852, he dwelt on the pathos of the emigration movement, then at its height, depicting the reactions of various types of emigrants aboard the *Eldorado*: an educated middle-class couple brood on 'all they are now giving up', a greengrocer's family 'makes the best of things', and a reprobate 'shakes his fist, with curses, at the land of his birth'. *Work* (1852–63, City Art Gallery, Manchester), based on the ideas of Carlyle and F. D. Maurice, who are portrayed in it, praised labour in all its aspects, and pointed to the social obligations of the rich. Brown taught at Maurice's Working Men's College from 1858 to 1860 and in the winter of the latter year set up a soup kitchen in his own house. Both pictures show an interest in the variety of human

character and especially in its physiognomic expression. Although he published long glosses on his pictures, Brown explained in *The Germ* and later when teaching that he tried to make a subject 'manifest itself to the ordinary observer without further explanation', and by studying expression he probably succeeded better than, for example, Hunt, who used a more private language of symbolic attributes. The subject of *Work* and the way it is illustrated by several linked incidents is reminiscent of Hogarth, whom Brown revered as 'the originator of moral invention and drama in modern art'.

After about 1865 Brown returned to the historical and literary subjects of his youth, and painted in a more florid manner, partly influenced by the later works of Rossetti. In Ford Madox Hueffer's words, his pictures now became 'pictures of balanced masses as opposed to pictures of combined details'. To some extent this broader style was demanded by the main activity of his later years, the decoration of Manchester Town Hall with murals depicting the city's history (1878–93).

The Pre-Raphaelites had a following of a sort. Impressed by Millais' scenes of lovers' meetings, Arthur Hughes (1830–1915) painted several pictures on the theme, though he used colour more emotively. A predominance of blues and greens pointed the tragedy of Hughes' lovers, trapped by ivy within frames shaped like grave-stones. In *Aurora Leigh's Dismissal of Romney* ('*The Tryst*') (finished 1860, pl.24) love is unrequited, in *April Love* (1855–6, pl.23) fragile, liable to be 'hurt with jar and fret', in *The Long Engagement* (1853–9, City Museum and Art Gallery, Birmingham) unconsummated, and in *Fair Rosamund* (c. 1854, National Gallery of Victoria, Melbourne) illicit and fatal. *Too Late* (1857–8, pl.21) by the Liverpool artist William Lindsay Windus (1822–1907), who was also initially influenced by Millais, depicts more starkly the belated return of a lover to a woman dying of consumption. In *The Second Duchess* (before 1866, Tate Gallery), portraying the corruption of a Renaissance court, he

came closer in style and subject to Rossetti. Henry Wallis (1830–1916) was equally morbid in *Chatterton* (1856, pl.27): 'Cut is the branch that might have grown full straight'. By contrast, *Kit's Writing Lesson* (1852, pl.25) by Robert Braithwaite Martineau (1826–69)—surprisingly a pupil of Hunt—is little more than a genre scene, and *The Last Day in the Old Home* (finished 1862, Tate Gallery) an inventory. Walter Howell Deverell (1827–54), who was proposed as but not elected a member of the P.R.B. in 1850, contracted, said Hunt, 'the prevailing taste . . . of dwelling on the miseries of the poor, the friendless and the fallen'. His concern for these is shown in *The Irish Vagrants* (? 1853, Johannesburg Art Gallery) and possibly in *A Pet* (exh. 1853, pl.26).

Devotion to detail was taken to extremes in landscape painting. William Dyce (1806–64), an early disciple of the Nazarenes, introduced minutely studied backgrounds into his religious pictures in the 1850s and painted one major landscape, *Pegwell Bay, Kent—A Recollection of October 5th 1858* (1859–60, pl.28), though this is rather sombre compared with Hunt's and Brown's landscapes and shows him thinking still in terms of local, not reflected colour. Thomas Seddon (1821–56) accompanied Hunt in Palestine in 1854, following his precepts in *Jerusalem and the Valley of Jehoshaphat* (1854, pl.29). In *Glacier of Rosenlaui* (1856, pl.30) John Brett (1830–1902), who was also an amateur scientist, achieved the patient geological accuracy which Ruskin preached.

Rossetti enjoyed a much greater influence than either Hunt or Millais. William Morris (1834–96) and Edward Burne-Jones (1833–98), who met as undergraduates at Oxford, attached themselves to him in 1856 and worked with him on the decoration of the Oxford Union in the following year. The medievalism of Morris' early poetry and of his only surviving easel picture, *Queen Guinevere* (1858, pl.34), owed much to Rossetti. Partly under Ruskin's influence, however, it grew into a nostalgia for medieval, pre-industrial society as a whole, and led to his revival of handicrafts in an

attempt to re-create an art 'made by the people, and for the people, as a happiness to the maker and the user'. Burne-Jones' ideal world of legend and myth also came in the first place from Rossetti, but was enlarged by his admiration of Botticelli, Mantegna, and Michelangelo, and became more monumental in character, as in *King Cophetua and the Beggar Maid* (finished 1884, pl.33). Although this picture may have been intended as a 'symbolic expression of the Scorn of Wealth', ultimately Burne-Jones felt powerless to alter society and could offer only an alternative to it: 'Rossetti could not set it right and Morris could not set it right—and who the devil am I ? . . . I have learned to know beauty when I see it, and that's the best thing'. Despite their many differences, Burne-Jones was as haunted as the original Pre-Raphaelites by a feeling that 'The time is out of joint', but he found an answer in Aestheticism. Beginning as a concern with 'the real world', the Pre-Raphaelite movement had ended in escapism.

I William Holman Hunt
Our English coasts, 1852
(*'Strayed Sheep'*) (detail)

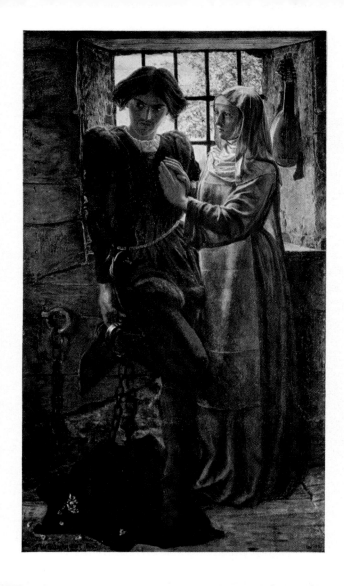

2 William Holman Hunt
Claudio and Isabella. 1850–3
Panel, 29¾ × 16⅞ in. (3447)

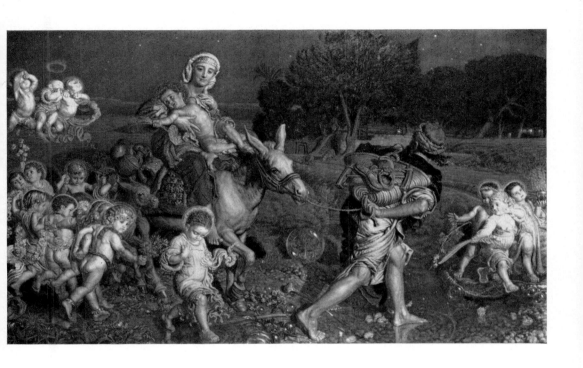

3 William Holman Hunt
The Triumph of the Innocents. 1883–4
Canvas. 61½ × 100 in. (3334)

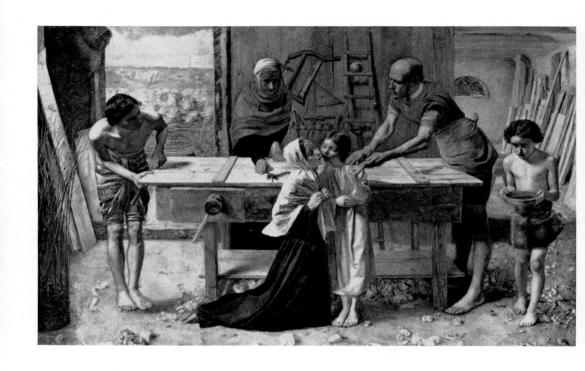

4 Sir John Everett Millais Bt.
Christ in the House of His Parents
1849–50 Canvas, 34 × 55 in. (3584)

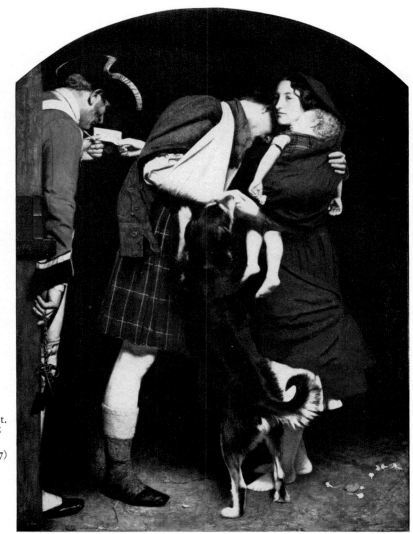

5 Sir John Everett Millais Bt.
The Order of Release, 1746
1852–3
Canvas, 40½ × 29 in. (1657)

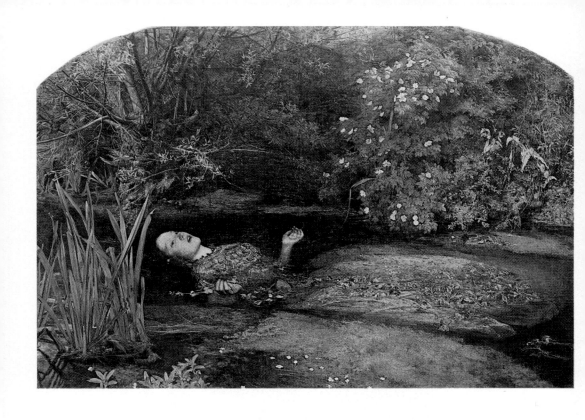

6 Sir John Everett Millais Bt.
Ophelia. 1851–2
Canvas, 30 × 44 in. (1506)

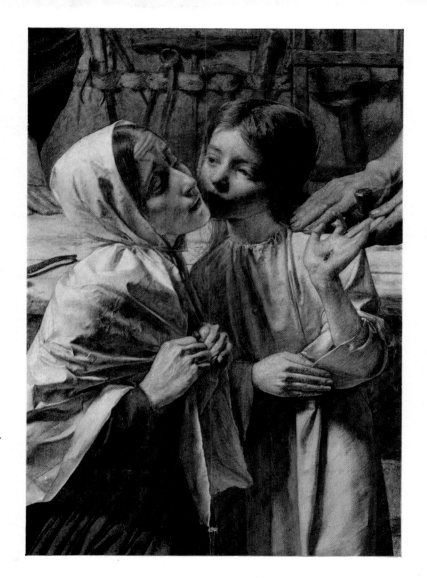

7 Sir John Everett Millais Bt.
Christ in the House of His Parents (detail)

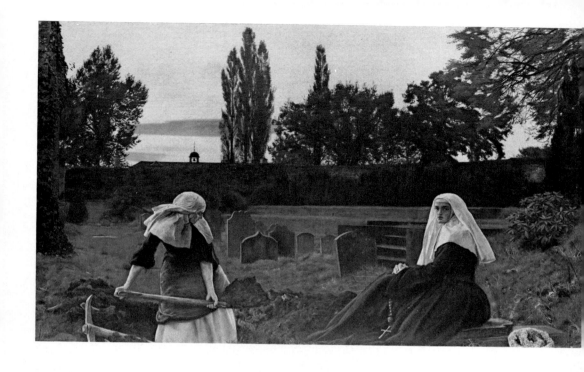

8 Sir John Everett Millais Bt.
The Vale of Rest. 1858–9
Canvas, 40½ × 68 in. (1507)

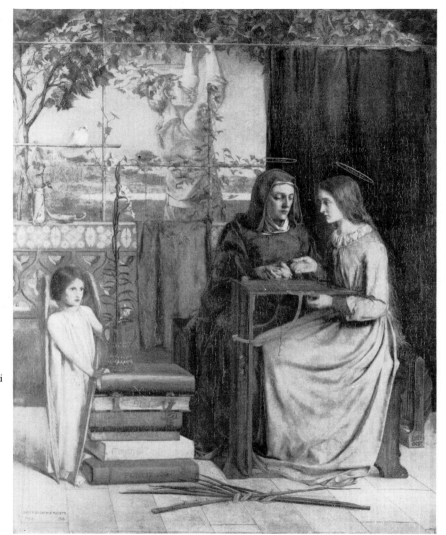

Dante Gabriel Rossetti
The Girlhood of Mary
1848–9
Canvas, $32\frac{3}{4} \times 25\frac{3}{4}$ in.
(4872)

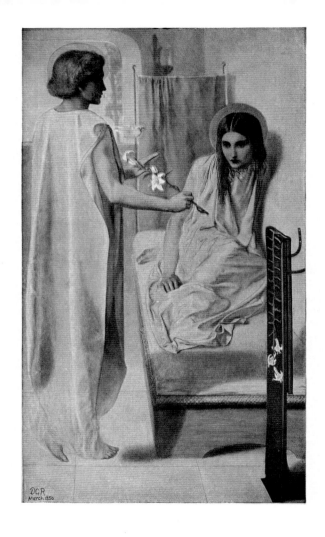

10 Dante Gabriel Rossetti
Ecce Ancilla Domini
(*The Annunciation*). 1849–50
Canvas, $28\frac{1}{2} \times 16\frac{1}{2}$ in. (1210)

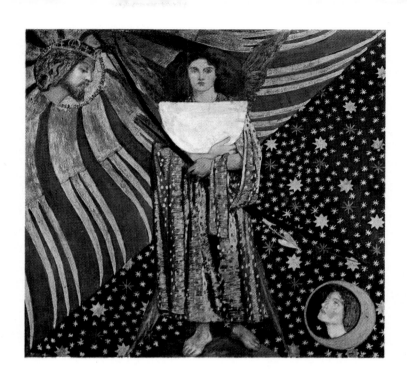

11 Dante Gabriel Rossetti
Dantis Amor. 1859
Panel, 29½ × 32 in. (3532)

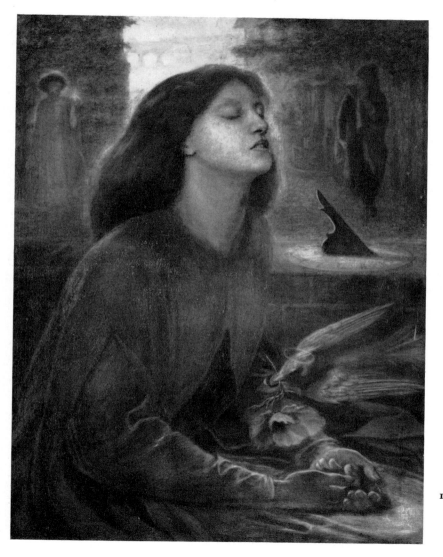

12 Dante Gabriel Rossetti
Beata Beatrix
Begun 1863
Canvas, 34 × 26 in.
(1279)

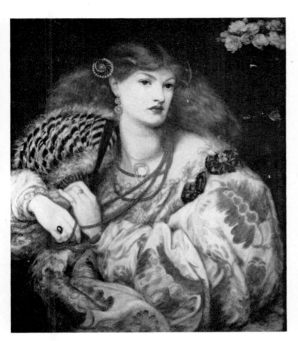

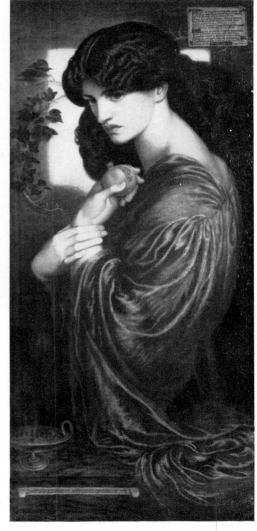

13 Dante Gabriel Rossetti
Monna Vanna. 1866
Canvas, 35 × 34 in. (3054)

14 Dante Gabriel Rossetti
Proserpine. 1874
Canvas, $49\frac{1}{4}$ × 24 in. (5064)

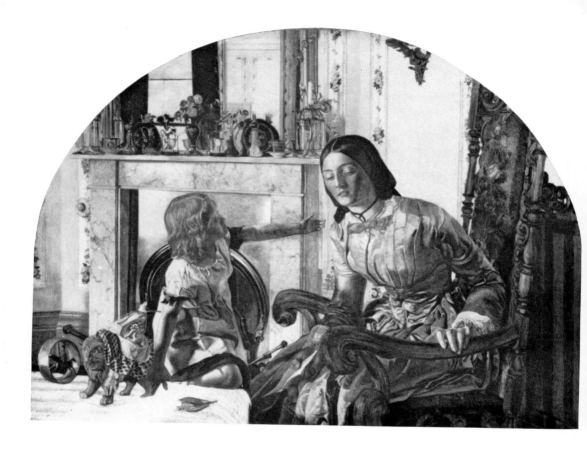

15 Frederic George Stephens
Mother and Child. c. 1854–5
Canvas, 18⅞ × 25⅛ in. (4634)

16 Dante Gabriel Rossetti
*The Wedding of St. George and
Princess Sabra.* 1857
Watercolour, 14 × 14 in. (3058)

17 James Collinson
The Empty Purse
replica of *For Sale. c.* 1857
Canvas, 24 × 19¾ in. (3201)

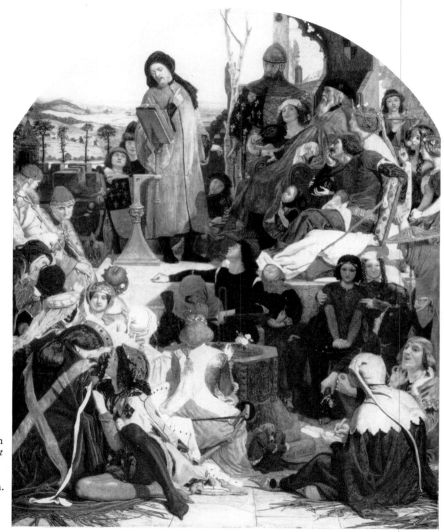

8 Ford Madox Brown
*Chaucer at the Court
of Edward III*
1856–67
Canvas, $48\frac{1}{2} \times 39$ in.
(2063)

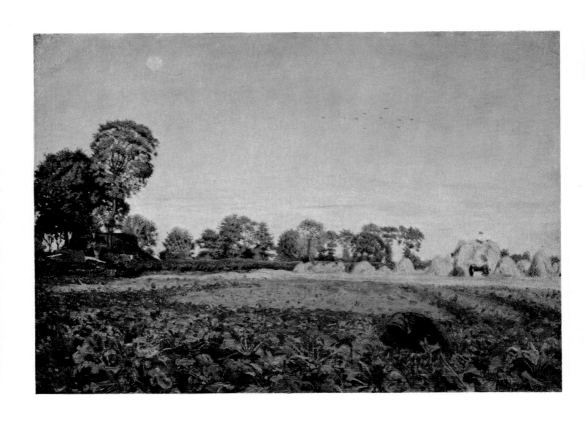

19 Ford Madox Brown
Carrying Corn. 1854
Panel, $7\frac{3}{4} \times 10\frac{7}{8}$ in. (4735)

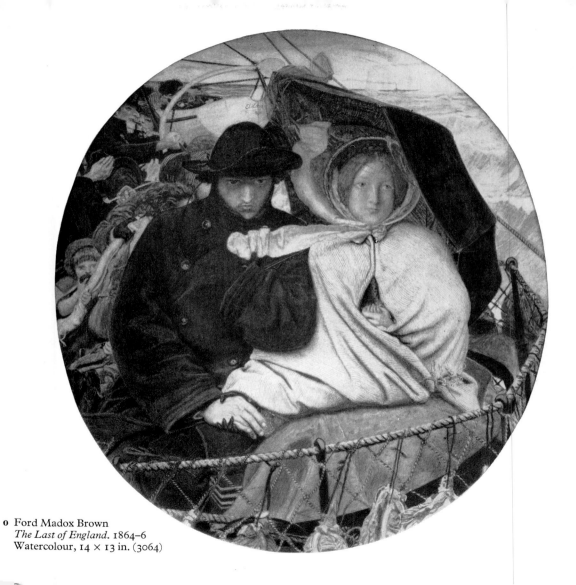

o Ford Madox Brown
The Last of England. 1864–6
Watercolour, 14 × 13 in. (3064)

21 William Lindsay
Windus
Too Late. 1857–8
Canvas, 37½ × 3
(3597)

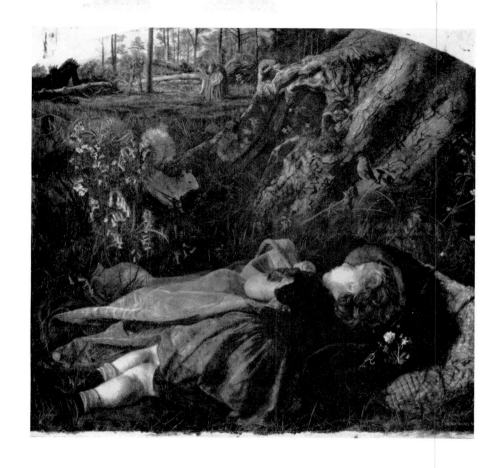

22 Arthur Hughes
The Woodman's Child. 1860
Canvas, 24 × 25¼ in. (T.176)

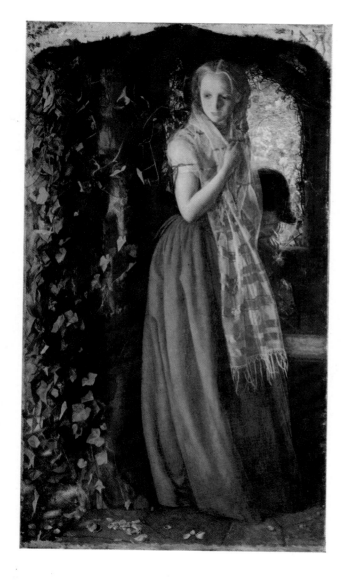

23 Arthur Hughes
April Love. 1855–6
Canvas, 35 × 19½ in. (2476)

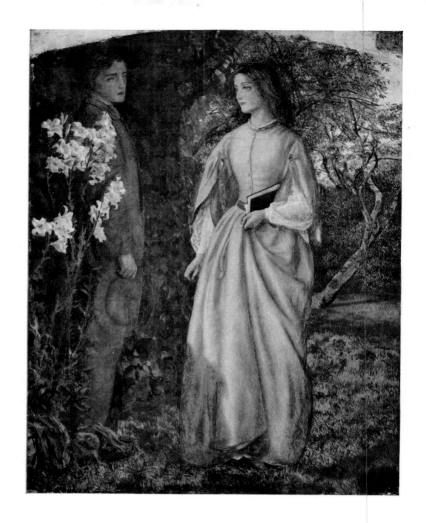

4 Arthur Hughes
*Aurora Leigh's Dismissal of
Romney* ('*The Tryst*').
Finished 1860
Panel, 15¼ × 12 in. (5245)

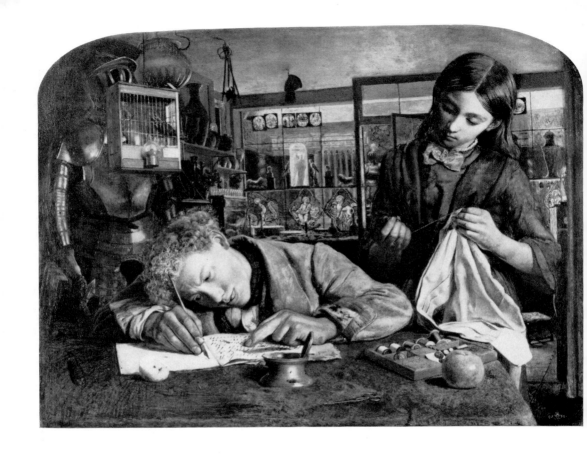

25 Robert Braithwaite Martineau
Kit's Writing Lesson. 1852
Canvas, 20½ × 27½ in. (T.11)

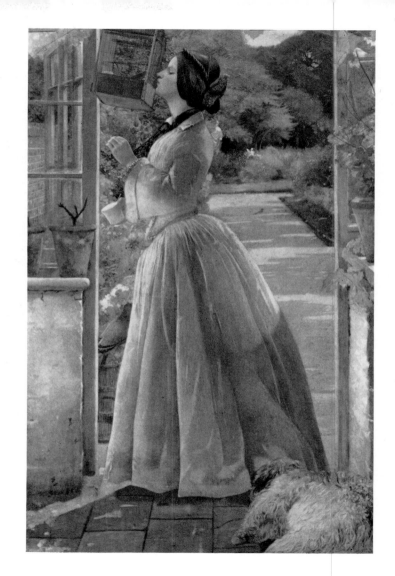

26 Walter Howell Deverell
A Pet. Exhibited 1853
Canvas, $38\frac{1}{8} \times 22\frac{1}{2}$ in. (2854)

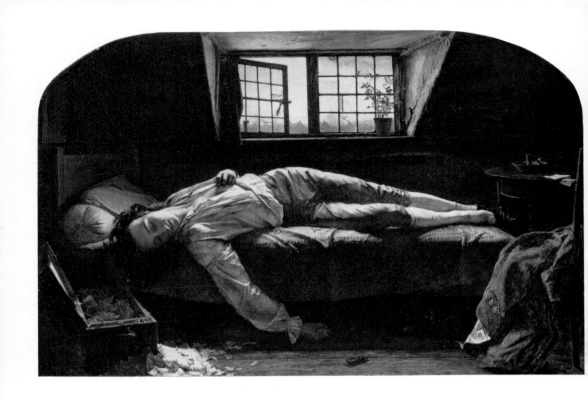

27 Henry Wallis
Chatterton. 1856
Canvas, 24½ × 36¾ in. (1685)

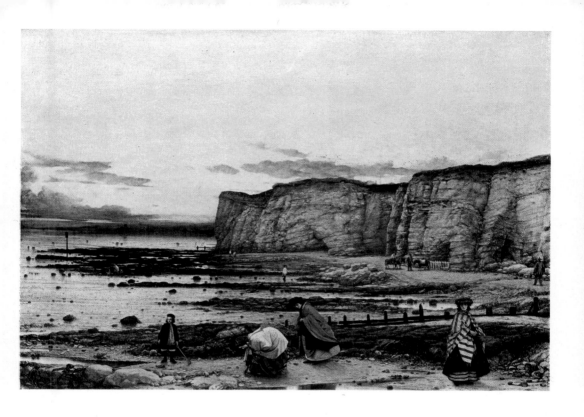

28 William Dyce
*Pegwell Bay, Kent—A Recollection
of October 5th 1858*. 1859–60
Canvas, 25 × 35 in. (1407)

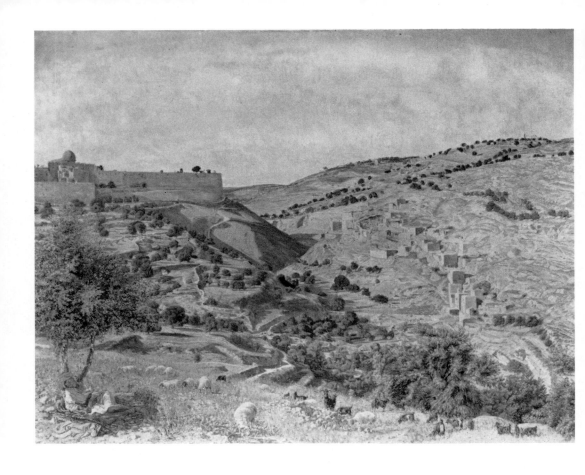

29 Thomas Seddon
*Jerusalem and the Valley of
Jehoshaphat.* 1854
Canvas, 26½ × 32¾ in. (563)

30 John Brett
Glacier of Rosenlaui. 1856
Canvas, 17½ × 16½ in. (5643)

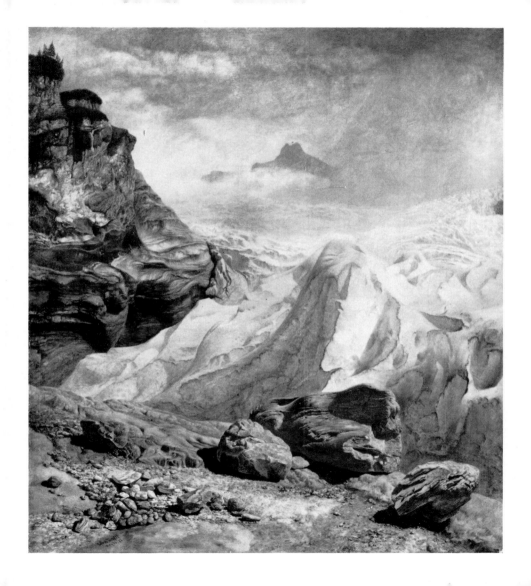

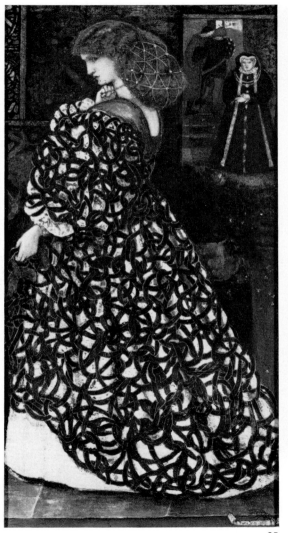

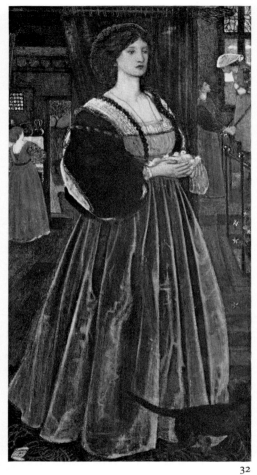

31

32

Sir Edward Burne-Jones Bt.
Clara von Bork, 1560. 1860
Watercolour, 13¼ × 7 in. (5878)

Sir Edward Burne-Jones Bt.
Sidonia von Bork, 1560. 1860
Watercolour, 13 × 6¾ in. (5877)

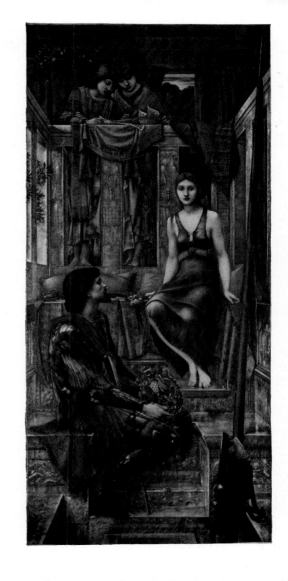

33 Sir Edward Burne-Jones Bt.
King Cophetua and the Beggar Maid
Finished 1884
Canvas, 115½ × 53½ in (1771)

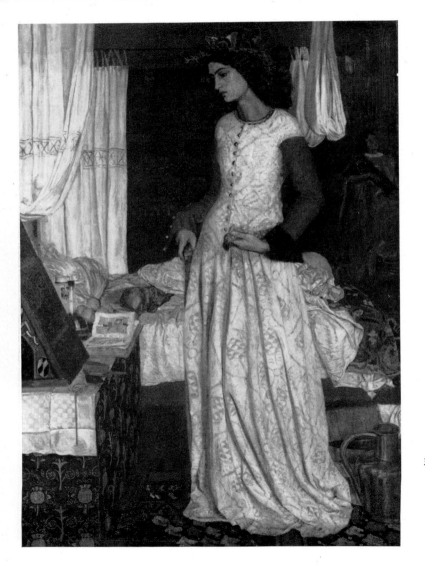

34 William Morris
Queen Guinevere. 1858
Canvas, $28\frac{1}{4} \times 19\frac{3}{4}$ in. (499